Put your hand in mine and let us help
one another to see things better.

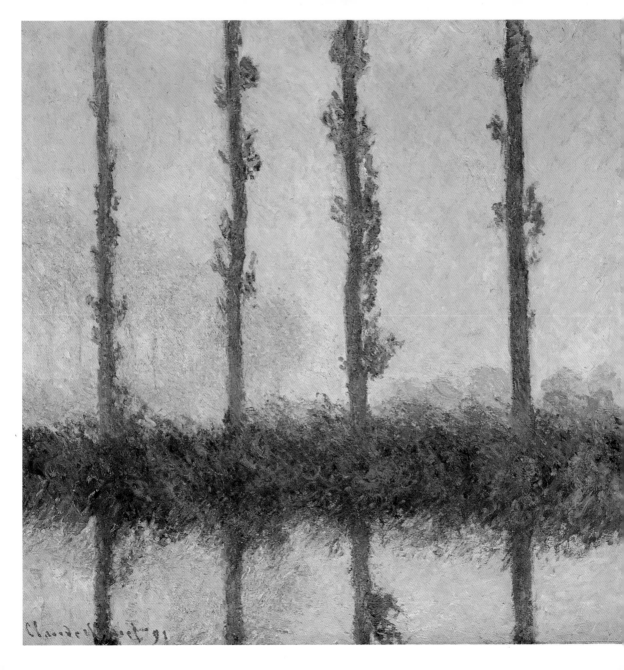

MONET
the artist speaks

EDITED BY GENEVIEVE MORGAN

CollinsPublishersSanFrancisco
A Division of HarperCollins*Publishers*

First published in USA 1996 by
Collins Publishers San Francisco
1160 Battery Street, San Francisco, CA 94111
Copyright © 1996 by Collins Publishers San Francisco
HarperCollins Web Site: http://www.harpercollins.com
HarperCollins®, ▤ ® and CollinsPublishersSanFrancisco™
are trademarks of HarperCollins Publishers Inc.
Design: Kari Perin
Design and Production Coordination: Kristen Wurz

Library of Congress Cataloging-in-Publication Data
Monet, Claude, 1840–1926.
Monet, the artist speaks / edited by Genevieve Morgan.
p. cm.
Includes index.
ISBN 0-00-225206-6
1. Monet, Claude, 1840–1926--Aesthetics.
2. Painting--Psychology. I. Morgan, Genevieve. II. Title.
ND553.M7A2 1996
759.4--dc20 95-38392
 CIP

Printed in China
10 9 8 7 6 5

The editor gratefully acknowledges the following sources:

House, John. *Monet: Nature into Art.* (New Haven &
London: Yale University Press). Copyright 1986 by Yale
University.

Mount, Charles Merrill. *Monet.* (New York: Simon &
Schuster). Copyright 1966.

Setiz, William C. *Monet.* (New York: Abrams). Copyright
1982.

Stuckey, Charles, ed. *Monet: A Retrospective.* (New York:
Beaux-Arts Edition). Copyright 1985 Hugh Lauter
Levin Associates, Inc.

Tucker, Paul Hayes. *Claude Monet: Life and Art.* (New
Haven: Yale University Press). Copyright 1995.

Exhibition catalog. *Claude Monet at the time of Giverny.*
(Paris: Center Culturel du Marais). Copyright 1983.

Exhibition catalog. *Monet: Late Paintings of Giverny
from the Musée Marmottan.* Organized by the New
Orleans Museum of Art and the Fine Arts Museum
of San Francisco. Distributed by Abrams. Copyright
1994 by the Fine Arts Museum of San Francisco.

Exhibition catalog. *Monet's Years at Giverny: Beyond
Impressionism.* Organized by The Metropolitan Museum
of Art. (New York: MET). Copyright 1978 by The
Metropolitan Museum of Art.

In addition, the editor wishes to thank Liz Weissberg
at Artists Rights Society; Jenny Barry, Maura Carey
Damacion, Katie Morris, Kari Perin, Carole Vandermeyde,
and Kristen Wurz at Collins Publishers; each of the
institutions and their personnel who graciously gave their
time and permission to reproduce images from their
collection; and finally, a special thanks to the estate of
Claude Monet for granting permission to use the artist's
works and writing.

INTRODUCTION

Claude Monet (1840–1926) was absolutely, passionately in love with nature. His painting, his writing, his conversation all resonate with his need to represent nature *exactly* as he saw it from one moment to the next. It is not an exaggeration to say that Claude Monet taught the world to see. Impressionism, with its mere hint of subject and vivid new palette of colors, saturated the process of painting— altered its evolution—to such a degree that now when we look at Monet's work, it seems so familiar that we take his unique style for granted; we forget that before Monet, no one had attempted to capture such subtle vagaries of a landscape, the abrupt changes in light, the mood of the air on a particular day. Given his enormous present-day popularity, it is the greatest irony that Monet in his lifetime was filled with dissatisfaction with his own work. Although he was an extremely popular artist, and well-paid for his time, his letters and interviews crackle with his frustration at being unable to recreate on canvas the wonders before his eye.

Monet went to unimaginable lengths to get the perfect picture, often risking life and limb. Friend and art critic François Thiébault-Sisson recalls in his article "About Claude Monet" how Monet almost drowned trying to paint a storm off the coast of Belle-Île. After securing his easel to a cliff with ropes, Monet set his back to the wind and began to paint. "All of a sudden," Thiébault-Sisson relates, "an enormous wall of water tore him from his stool. Submerged and without air, he was about to be swept out to sea when a sudden inspiration caused him to drop his

palette and paintbrush and seize the rope that held his easel. This did not keep him from being tossed around like an empty barrel, and he would have dined with Pluto had chance not brought two fishermen to his rescue." For Monet, who traveled the world in search of different "effects," no challenge was too great.

Despite the thrill of his adventures (Norway, Holland, the Creuse, London, Venice, and Bordighera were only a few of his destinations), Monet loved to return home. His gardens, beginning with Argenteuil and culminating in Giverny, were his comfort and sustenance. In gardening he could orchestrate and nurture the natural world that so often seemed beyond his reach. It was also at home that Monet entertained a large group of friends, associates, interviewers, and writers. In addition to Thiébault-Sisson, the recollections of Monet's second wife, Alice Hoschedé, and his friends George Clemenceau, Paul Durand-Ruel, and Gustav Geffroy are presented here, among many others.

Cézanne is attributed with the famous saying "Claude Monet was only an eye. But what an eye." On the surface, it sounds flip. But Monet would have approved. He yearned to craft his vision into a perfect mirror of nature, painting only what was in front of him at that particular instant and investing the moment with no external meaning. This desire was the ecstasy and torment of Monet's life, for, in his own words, "it is nothing other than impossible." But as his friend the poet Octave Mirabeau once said of him, "All that matters is the end result."

—Genevieve Morgan

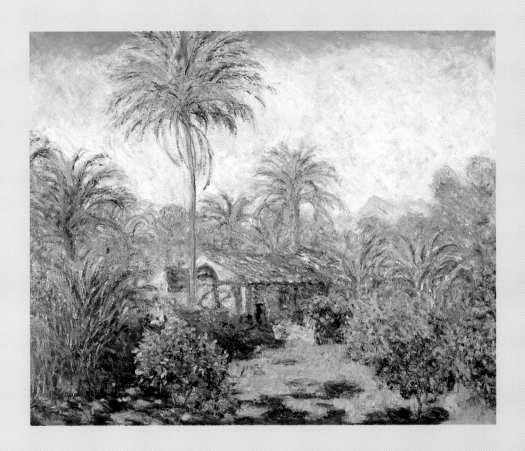

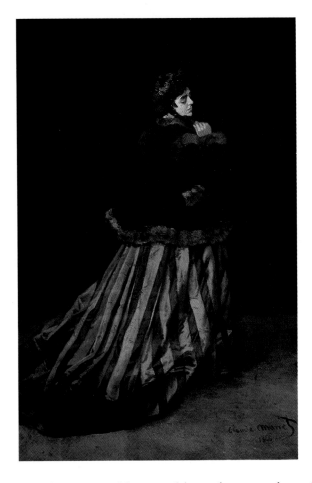

My art is an act of faith, an act of love and humility. Yes, humility. . . . I applied
paint to these canvases in the same way that monks of old illuminated
their books of hours; they owe everything to the close union of solitude and
silence, to a passionate and exclusive attention akin to hypnosis.

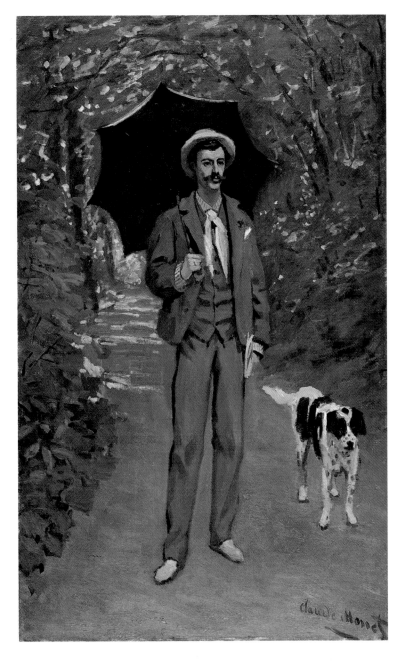

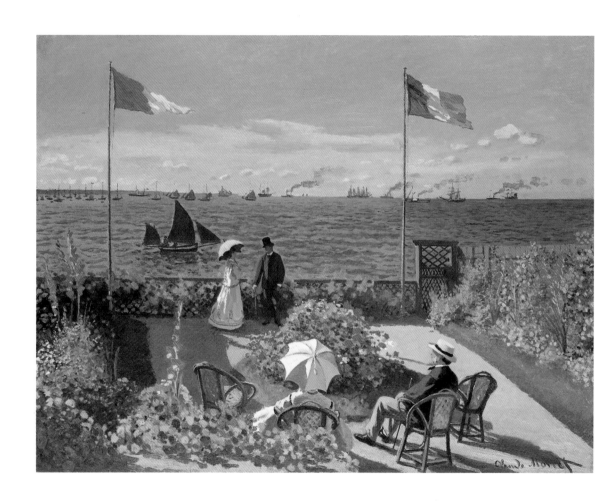

For quite a while my friends and I had been systematically rejected by the jury. What were we to do? It's not everything to paint—you have to sell, and live.

As for myself,

I met with as much success

as I could ever have wanted.

In other words,

I was enthusiastically run down

by every critic of the period.

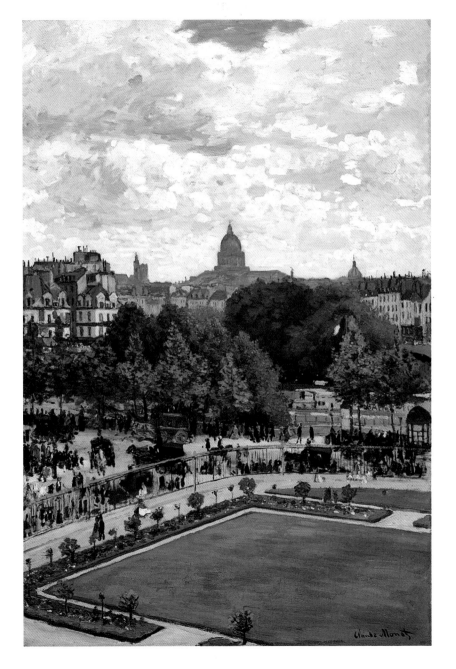

I would like to paint the way a bird sings.

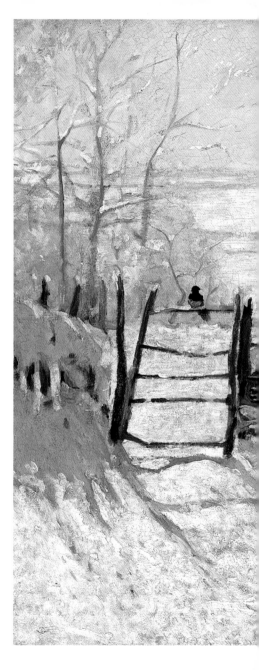

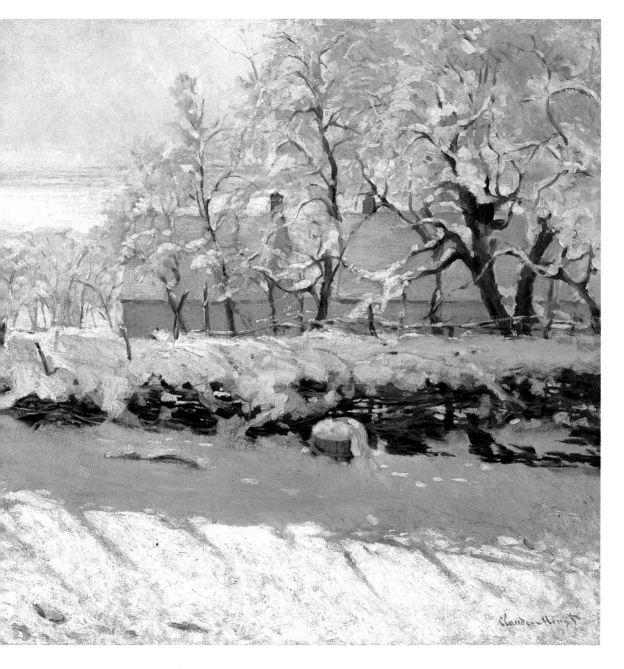

I've always done what I saw
without worrying too much
about the process.

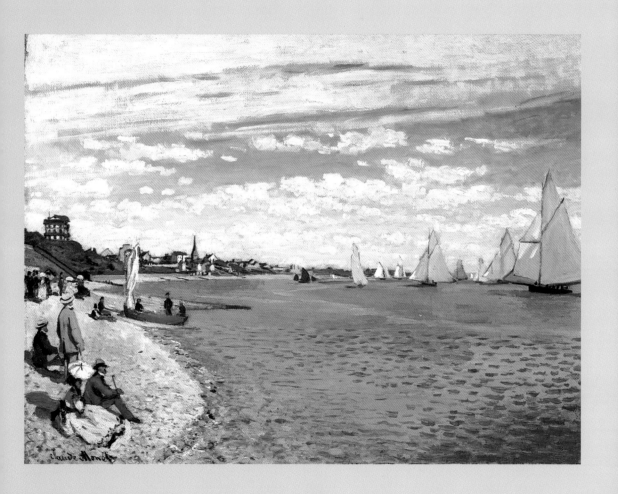

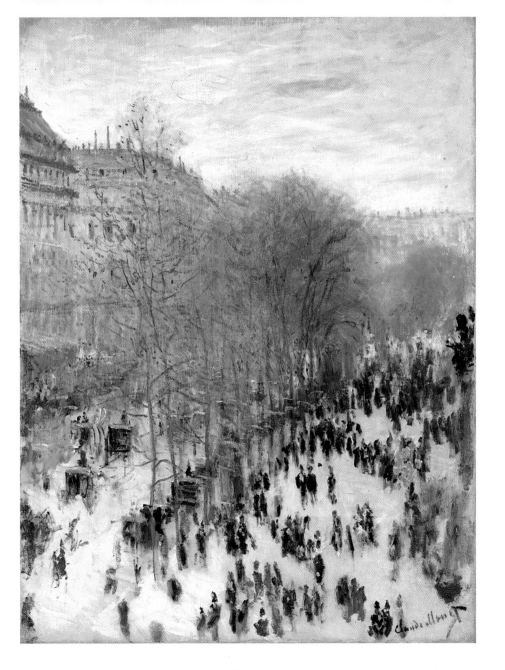

I can see more and more clearly that

I will have to work very hard to render

what I am looking for: the instantaneous

impression, particularly the envelope of

things, the same all-pervading light...

The richness I achieve comes from nature,
the source of my inspiration.

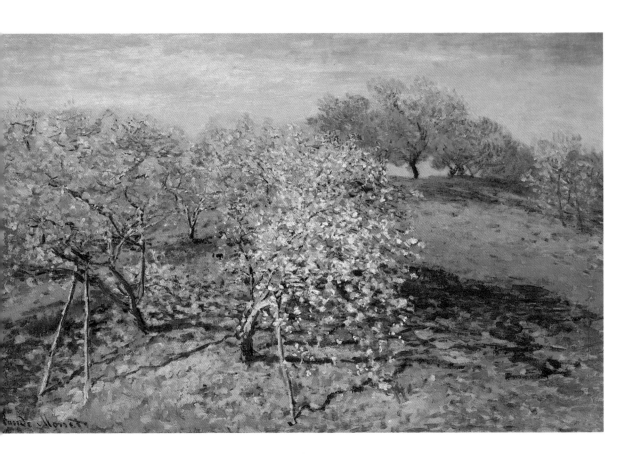

I have no other wish than to
mingle more closely with nature,
and I aspire to no other destiny than
to work and live in harmony
with her laws.

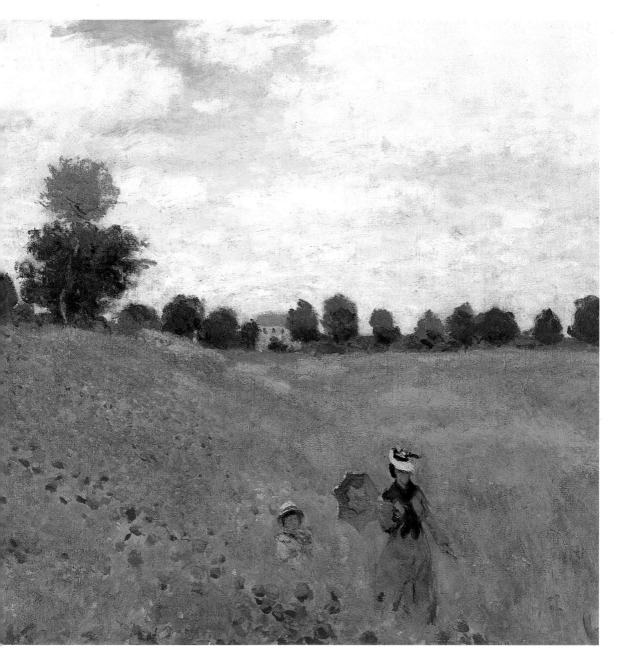

I perhaps owe it to flowers for having become a painter.

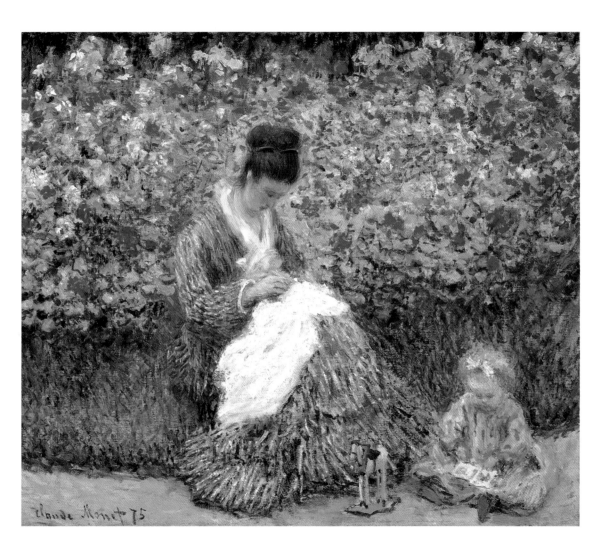

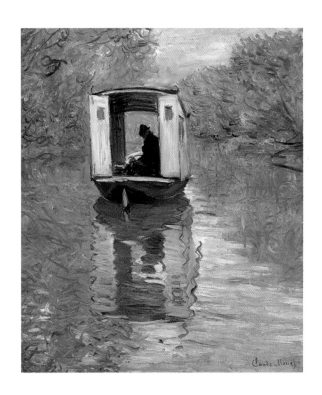

I want to paint the air

in which are situated

the bridge, the home, the boat.

The beauty of the air

where they are . . .

and it is nothing other

than impossible.

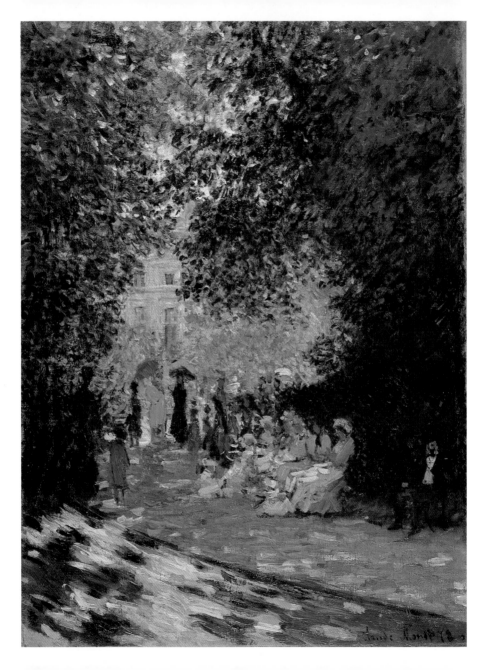

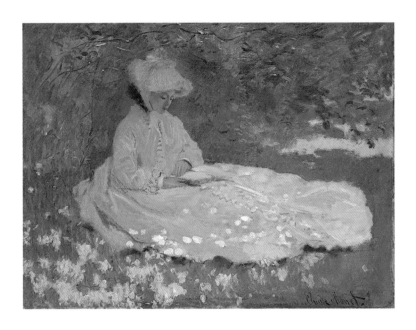

The real point is to know how to use colors,
the choice of which is basically no more than a question of habit.
I use the following: lead white, cadmium yellow, vermilion,
dark madder, cobalt blue, emerald green, and that is all.

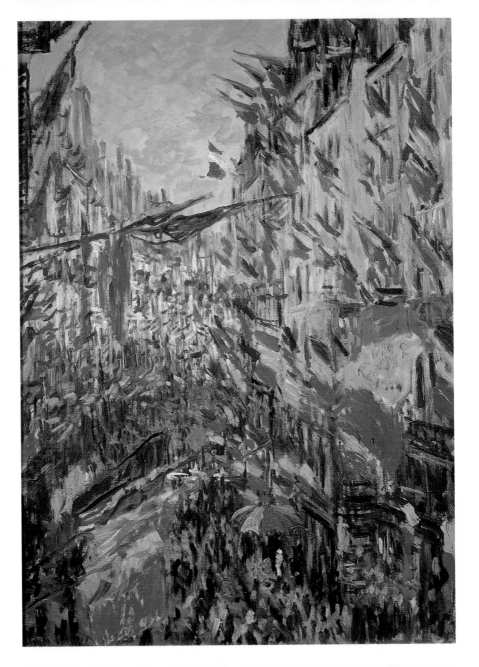

A landscape is only an impression,
instantaneous, hence the label they've given us—
all because of me, for that matter.

Happy are the young people who believe that it is easy.

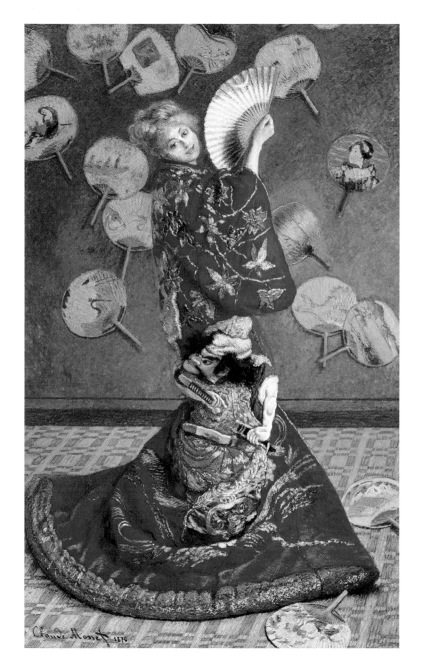

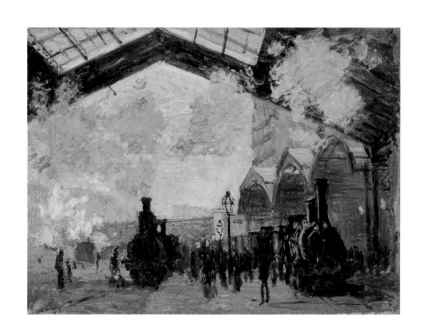

There are some painters who experience a morbid

satisfaction in doing that which goes against nature. . . .

They began by reproducing nature as it is . . .

and then all of a sudden, without apparent reason,

we see them turn their backs on reality. One can not

help but be filled with an inexpressible sadness.

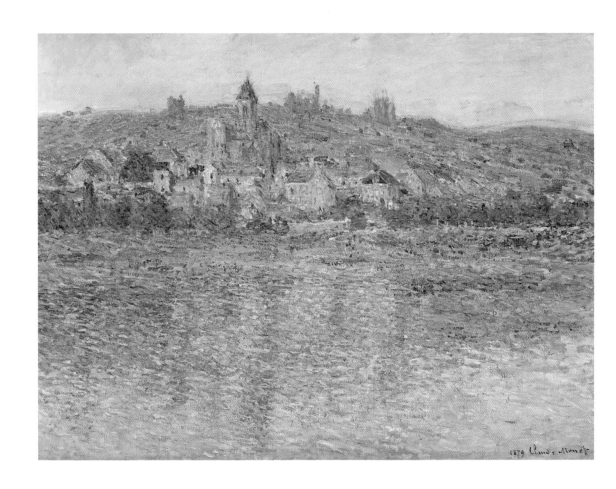

Everything is pigeon throated and punch ablaze.
It's wonderful.

I am very happy, very enchanted.
I am like a real cock in pâté, for I am surrounded here by
everything I love. . . . My desire would be to stay just like this
forever, in a quiet corner of nature.

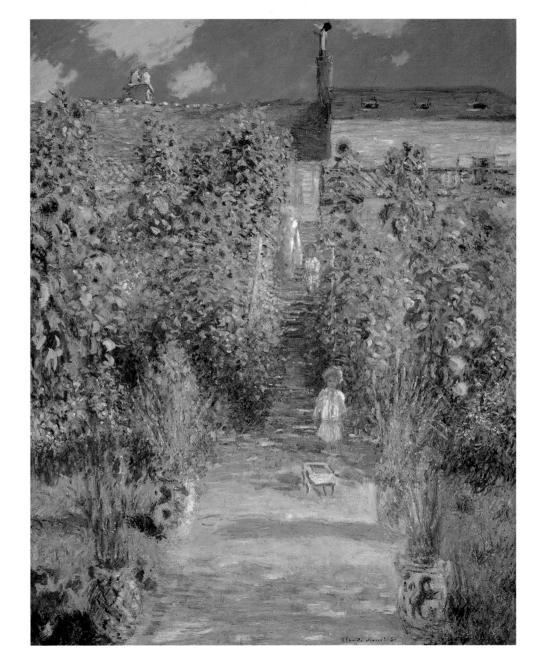

Nature does not stand still.

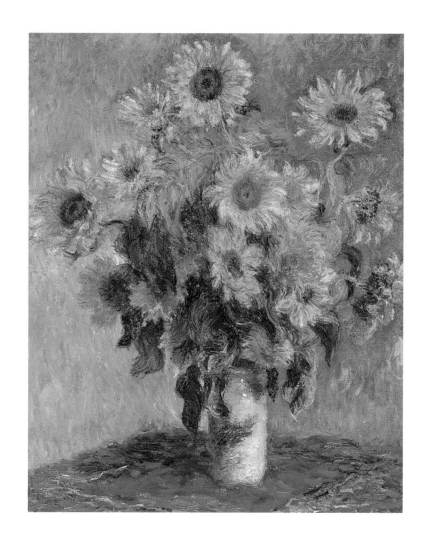

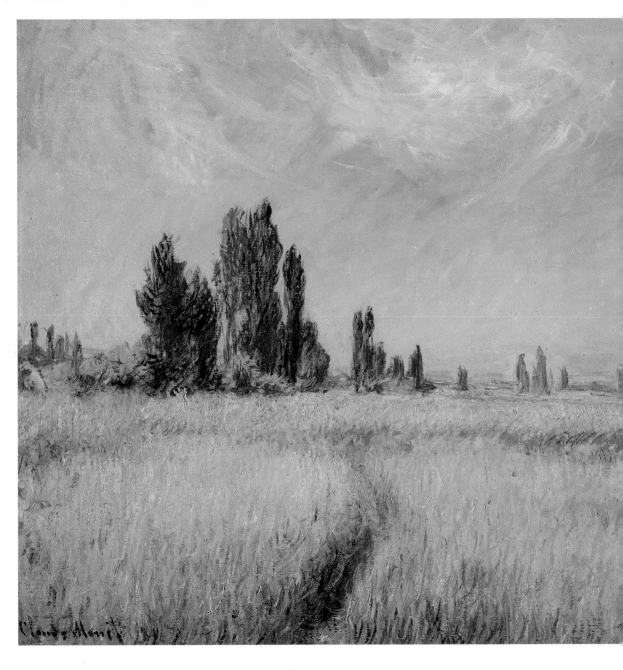

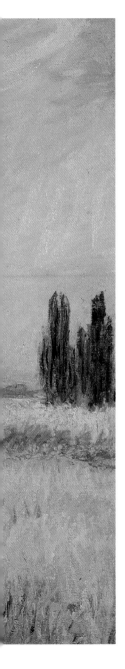

What a confounded profession is mine!
No matter what beautiful things I see,
it's far too difficult.

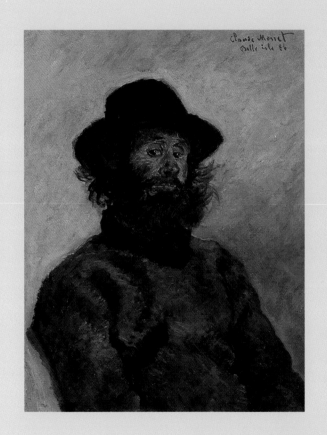

I've always worked

better in solitude . . .

following my

own impressions.

I want to be always before the sea or on it,
and when I die, to be buried in a buoy.

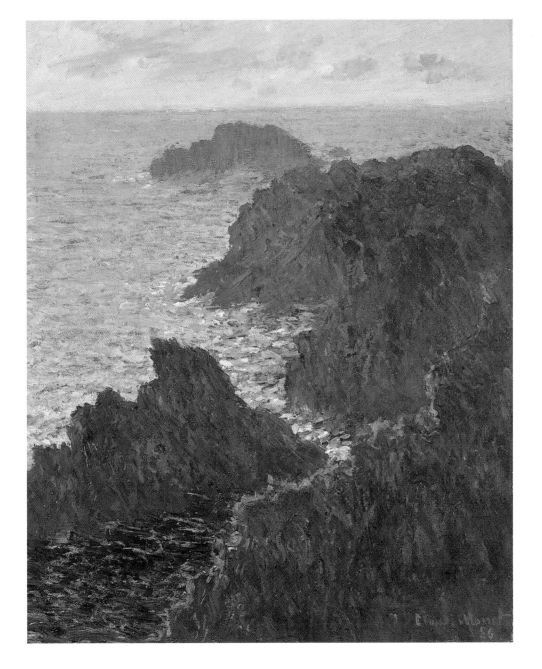

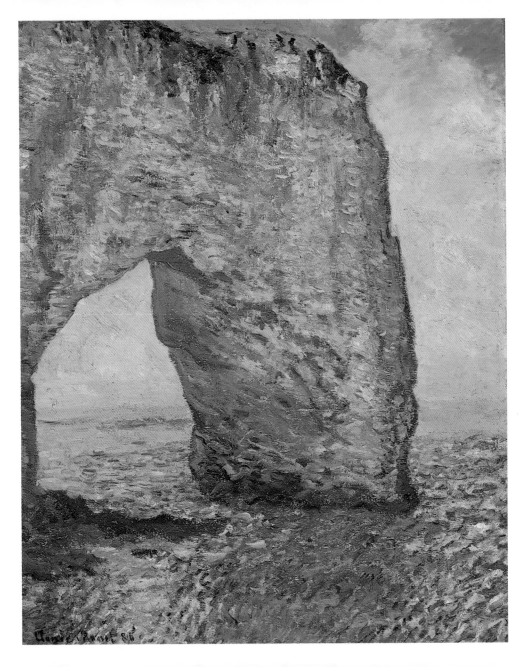

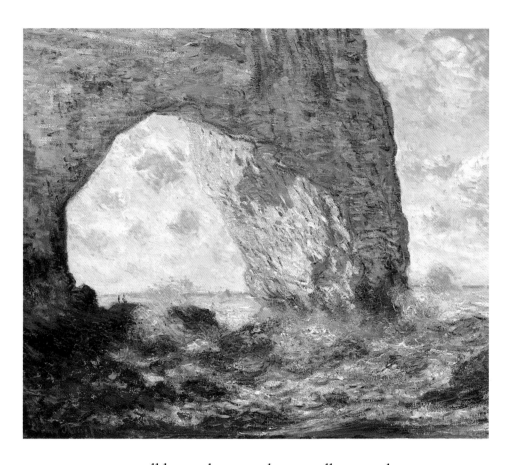

. . . yet I well know that in order to really paint the sea,
you have to see it every day, at every hour and in the same place,
to come to know the life in this location. Hence I do the same
subjects as many as four or six times over.

Nature is greatness, power, and immortality; compared with her, a creature is nothing but a miserable atom.

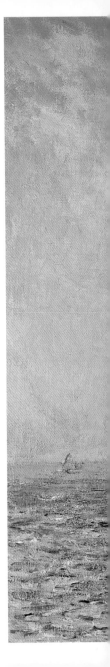

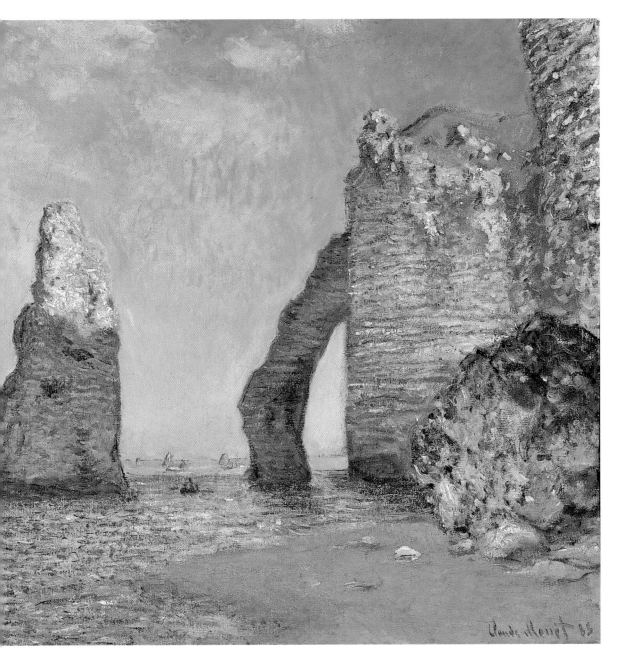

You'll understand, I'm sure, that I'm

chasing the merest sliver of color. It's my

own fault, I want to grasp the intangible.

It's terrible how the light runs out. Color,

any color, lasts a second, sometimes three

or four minutes at most.

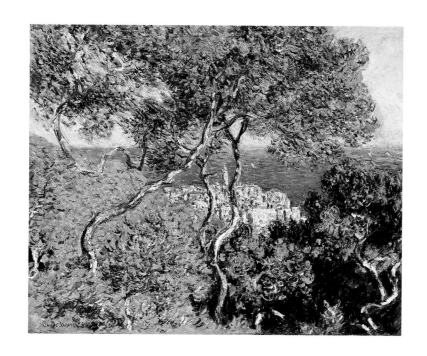

. . . no landscape is sadder nor more obsessing
than certain roundabouts in the Creuse during
the rainy, windy, cold months.

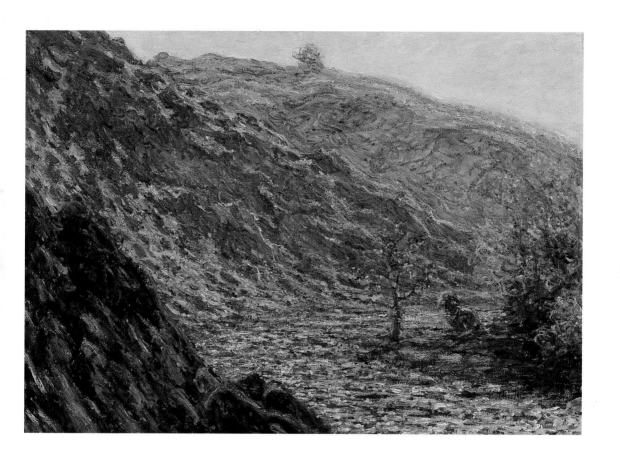

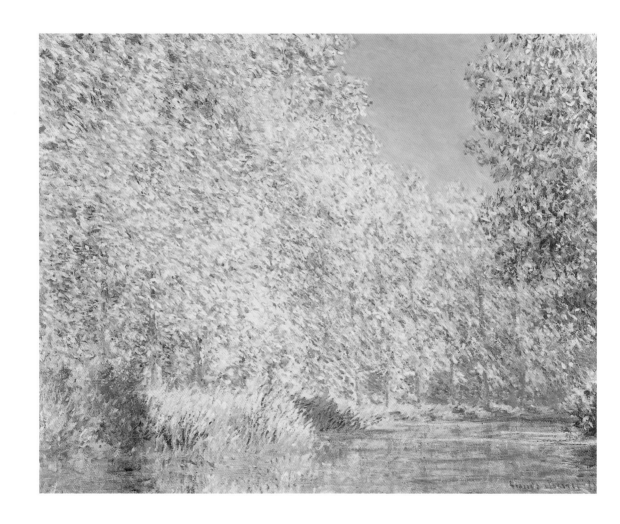

When you go out to paint, try to forget what objects
you have before you, a tree, a house, a field, or whatever. Merely think,
here is a little square of blue, here an oblong of pink, here a streak
of yellow, and paint it just as it looks to you . . .

A true painter can never be
happy with himself.

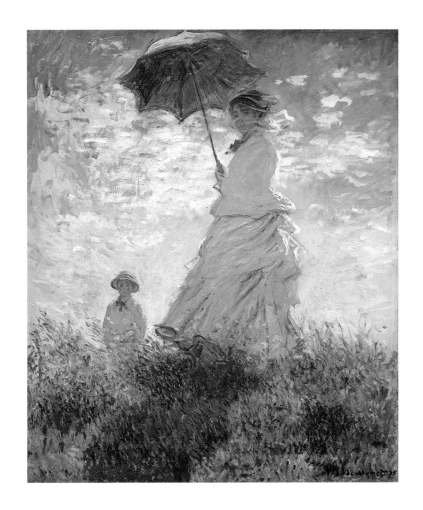

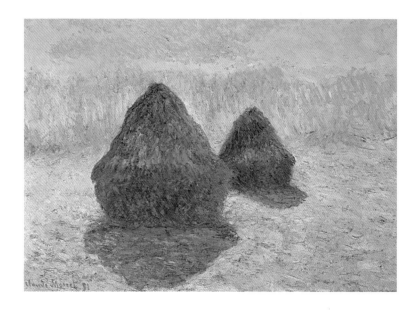

When I started, I was just like the others; I thought two canvases were enough—
one for a "gray" day, one for a "sunny" day. At that time I was painting haystacks
that had caught my eye; they formed a magnificent group, right near here.
One day I noticed that the light had changed. I said to my daughter-in-law, "Would
you go back to the house, please, and bring me another canvas?" She brought it to me,
but very soon the light had again changed. "One more!" and, "One more still!"

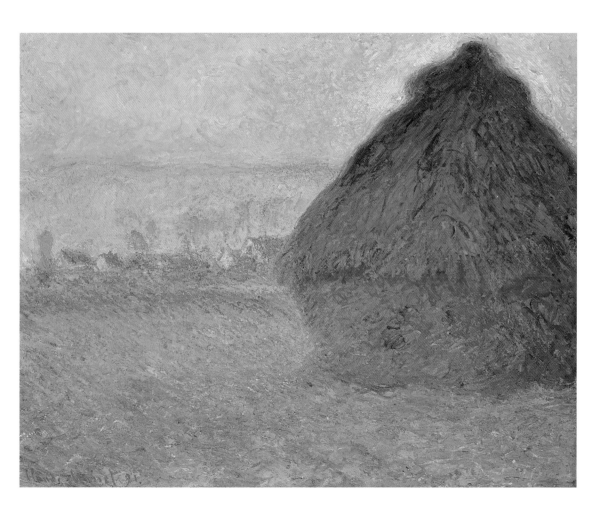

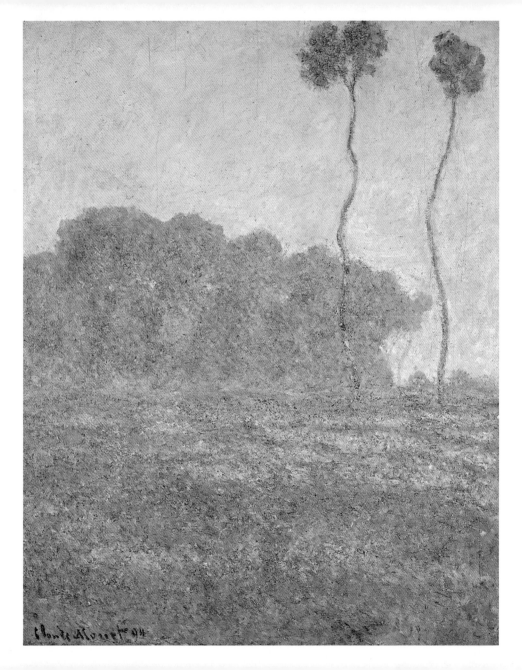

I am precisely the man of isolated trees and wide spaces.

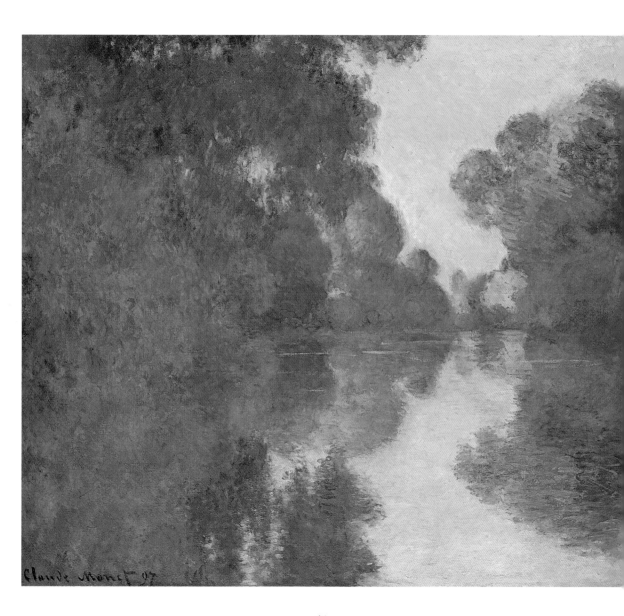

Claude Monet 97

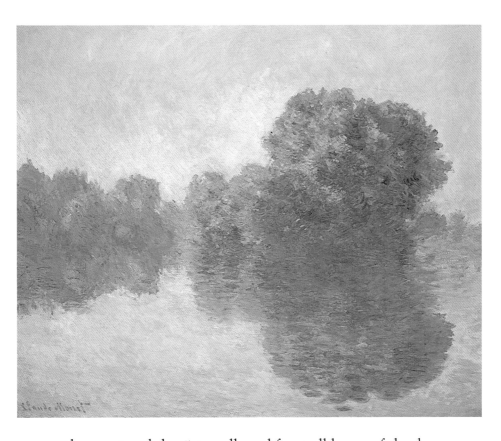

I have painted the Seine all my life, at all hours of the day,
and in every season. . . . I have never been bored with it:
to me it is always different.

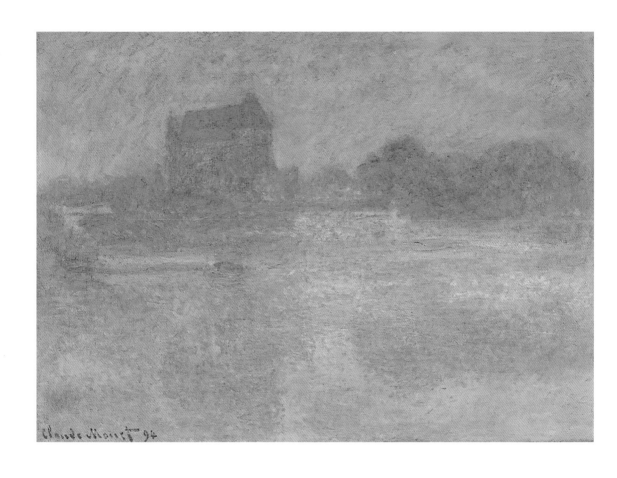

I discovered the curious silhouette of a church, and I undertook to paint it. It was the beginning of summer . . . fresh foggy mornings were followed by sudden outbursts of sunshine whose hot rays could only slowly dissolve the mists surrounding every crevice of the edifice and covering the golden stones with an ideally vaporous envelope.

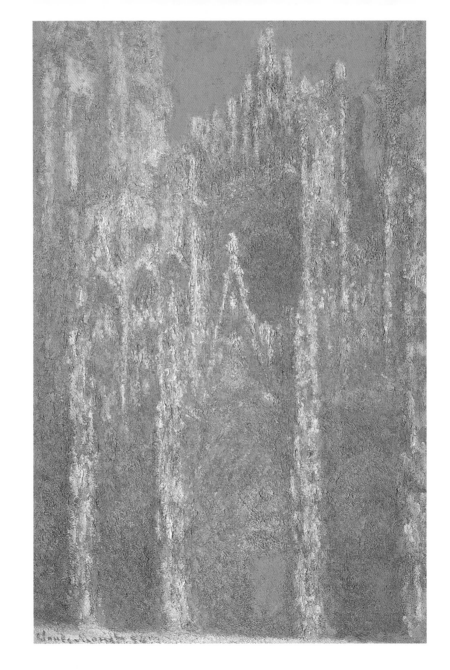

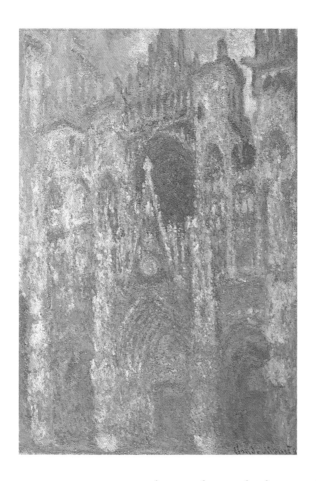

I'm worn out, I cannot go on, and something which never happens,
my sleep was filled with nightmares: the cathedral fell down on top of me,
it appeared either blue, pink, or yellow.

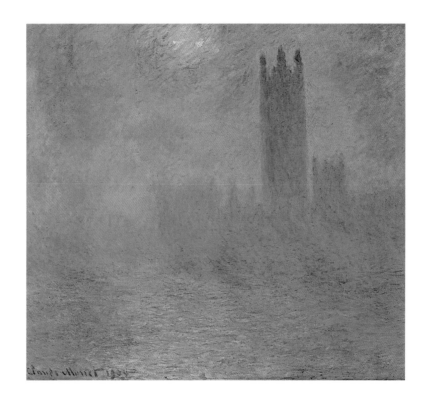

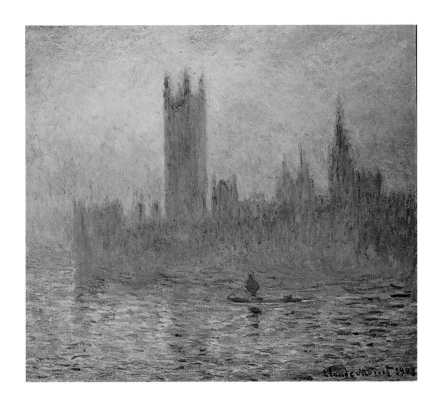

I cannot send you a single one of my London paintings because,
in the type of work I am doing, it is essential that I should have all of
them under my eyes . . . I work at all of them at the same time . . .

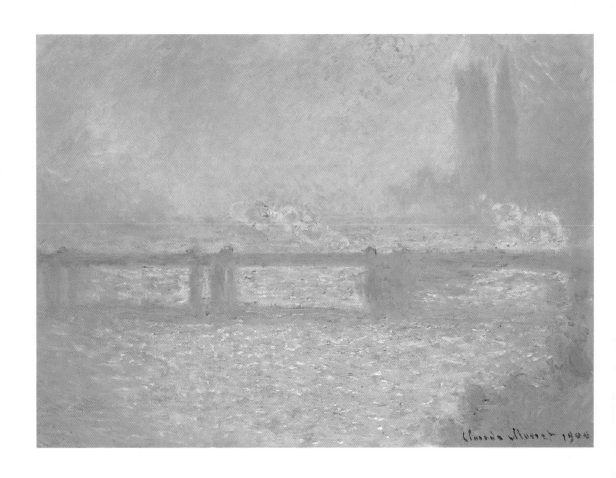

One day I am satisfied,

the next day I find it all bad;

still I hope that some day

I will find some of them good . . .

. . . I have only been able to make attempts, beginnings. But how unfortunate not to have come here when I was younger, when I was full of audacity!

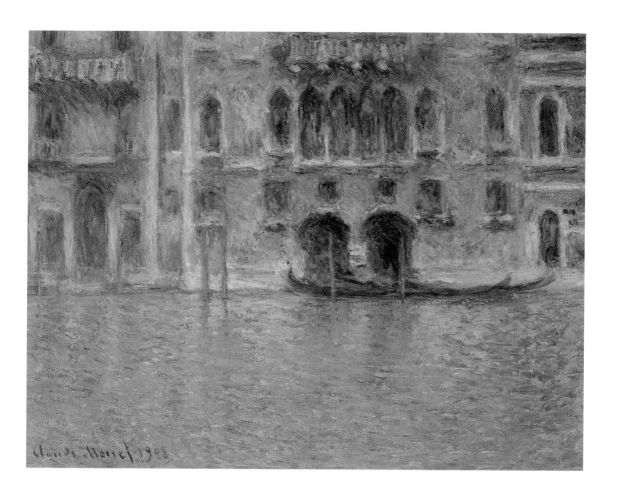

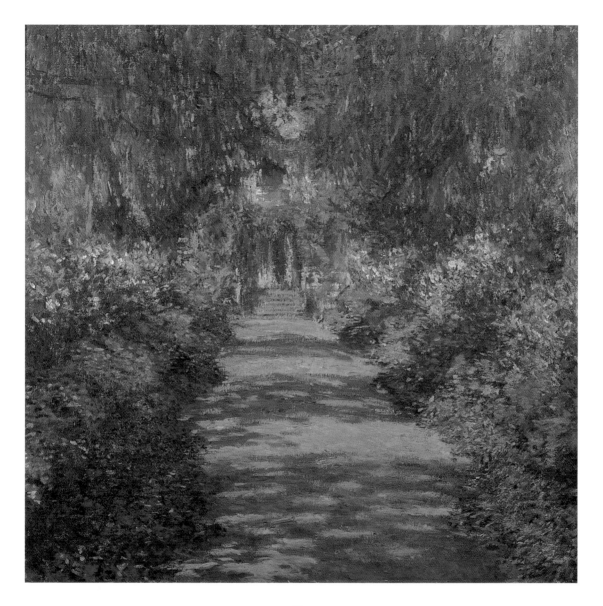

My studio! But I never have *had* one,

. . . I don't understand why anybody

would want to shut themselves up

in some room. Maybe for drawing,

sure; but not for painting.

Everything I have earned has gone into these gardens.
I do not deny that I am proud of them.

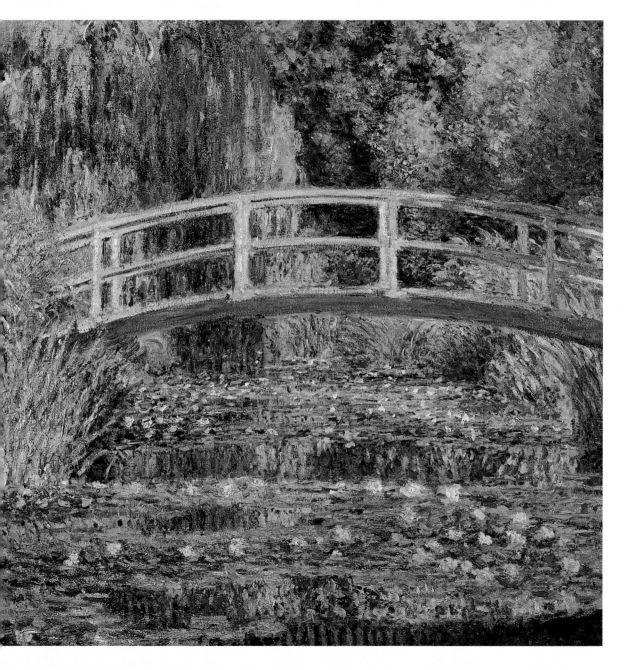

I have taken up things which are impossible to do:
water with grass undulating in the bottom. . . .
This is a wonderful thing to see but quite likely
to drive crazy anyone trying to render it. It is with
such things that I am always grappling!

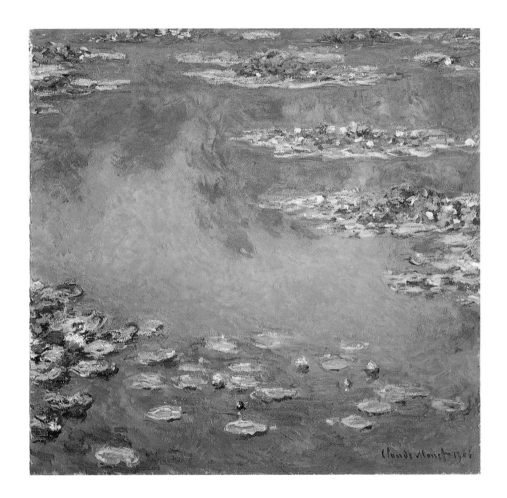

I had always loved the sky
and the water, greenery, flowers.
All these elements were
to be found in abundance here
on my little pond.

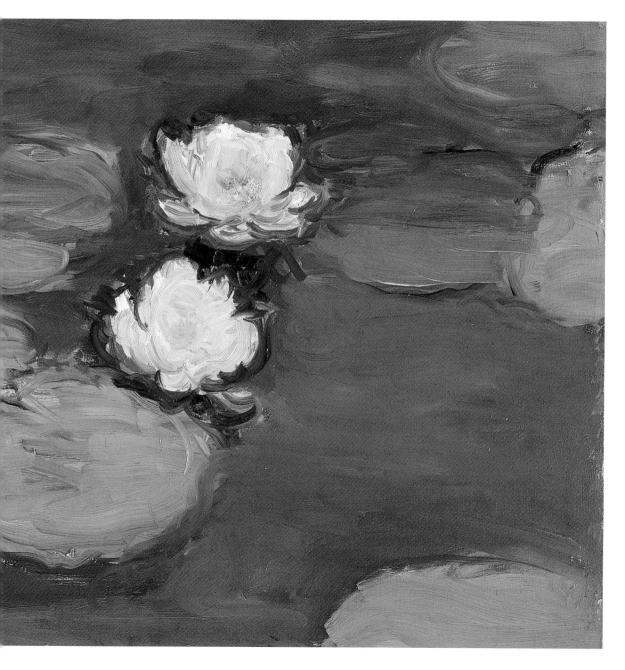

The basic element of the motif is the mirror of water, whose appearance changes at every instant because of the way bits of the sky are reflected in it, giving it life and movement. The passing cloud, the fresh breeze, the threat or arrival of a rainstorm, the sudden fierce gust of wind, the fading or suddenly refulgent light—all these things, unnoticed by the untutored eye, create changes in color and alter the surface of the water.

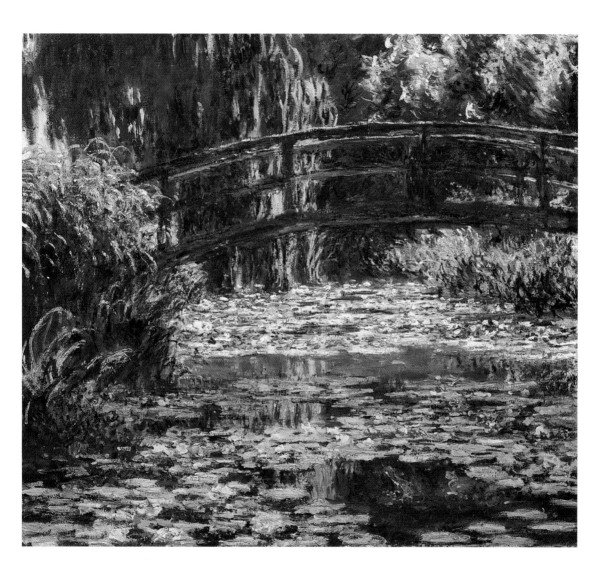

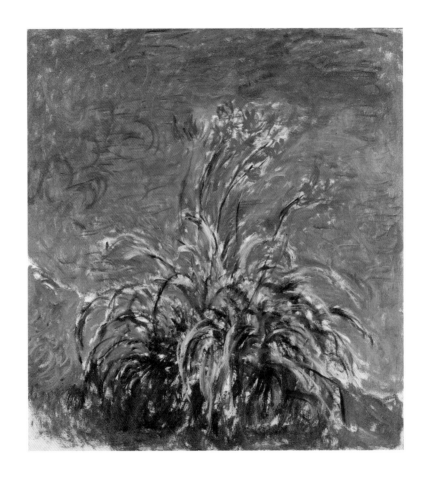

Nature is the most discerning

guide, if one submits oneself

completely to it, but when it

disagrees with you, all is finished.

One cannot fight nature.

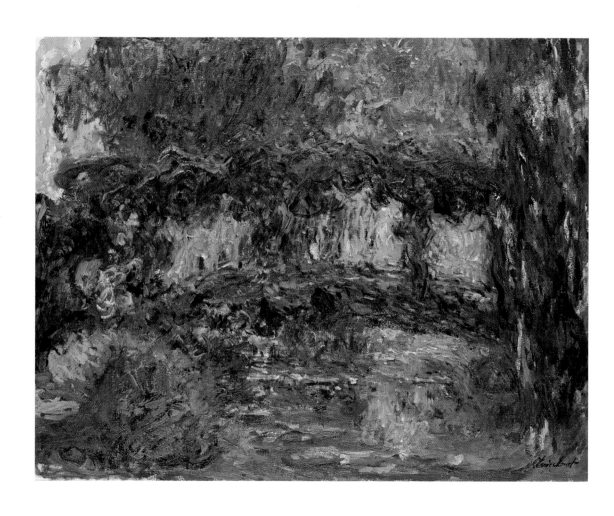

It will be said that I am mad. We will get there perhaps, but I have come too soon.

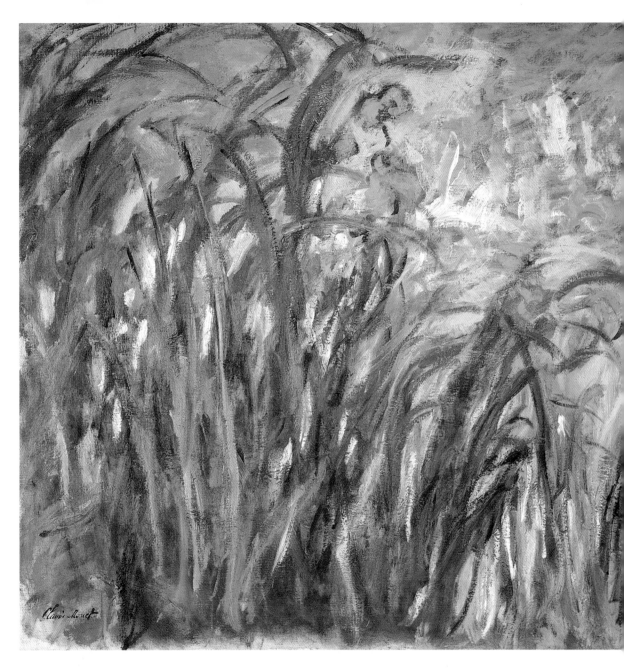

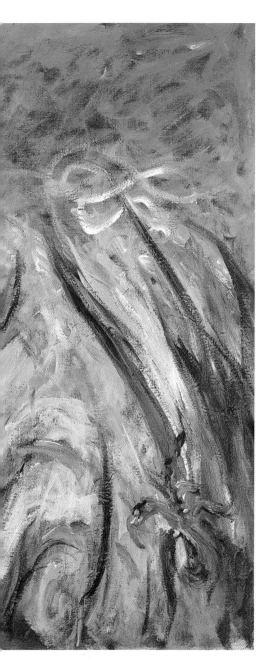

I only see blue.
I no longer see red . . . or yellow.
I know these colors exist because
I know that on my palette there is red,
yellow, a special green, a certain violet;
I no longer see them as I once did,
and yet I remember very well
the colors which they gave me.

N O T E S

1 A remark made at the end of Monet's life to his great friend and supporter George Clemenceau, in an essay by Clemenceau published in 1929. Reprinted in its entirety in *Monet: A Retrospective*. Charles Stuckey, ed. (New York: Beaux-Arts Edition). Copyright 1985 Hugh Lauter Levin Associates, Inc. Alternate translation from the same essay appears in *Claude Monet: Life and Art* by Paul Hayes Tucker (New Haven: Yale University Press). Copyright 1995.

5 Episode described by Monet's friend François Thiébault-Sisson in his article "About Claude Monet" published on January 8, 1927, in *Le Temps*. Reprinted in its entirety in *Monet: A Retrospective*.

6 (first line of last paragraph) Cezanne's famous exclamation regarding Monet appears throughout the literature on Monet. / (second to last line of last paragraph) See page 27 for entire phrase and credit. / (last line of last paragraph) Octave Mirabeau has written some beautiful descriptions of Monet's work and gardens. This remark appears in the preface to the exhibition catalog of Monet's London series shown in 1905. Reprinted in *Claude Monet at the time of Giverny*. Exhibition catalog (Paris: Center Culturel du Marais) Copyright 1983.

8 Exclamation recorded by Roger Marx, a journalist and collector of Impressionistic art. Quoted in his essay "M. Claude Monet's Waterlilies," published in 1909 in the *Gazette des Beaux-Arts*. Reprinted in *Monet: A Retrospective*.

11 Interview with Emile Taboreux in *La Vie Moderne*, dated June 12, 1880. Reprinted in *Claude Monet at the time of Giverny*.

12 Ibid.

14 A much repeated phrase of Monet's. Quoted in an essay by Maurice Guillemot, a friend and political and arts essayist in *La Revue Illustrée*, dated March 15, 1898. *Monet: A Retrospective*.

16 1927 comment quoted in "Pilgrimage à Giverny" by Duc de Trévise, published in the January/February edition of in *La Revue de l'art ancien et moderne*. Reprinted in *Monet: A Retrospective*.

19 From a letter dated October 7, 1890, to Monet's lifelong friend and biographer Gustav Geffroy who was at that time the art critic for the Parisian journal *La Justice*. Reprinted in *Claude Monet at the time of Giverny*.

20 1909, Marx.

22 Ibid.

24 Comment to influential art critic and writer François Thiébault-Sisson, founder of *La Justice*. Reprinted in *Claude Monet: Life and Art*.

27 Quoted in the journal of Hermann Bang, dated April 1895. Reprinted in *Claude Monet at the time of Giverny*.

29 Letter dated June 3, 1905, from Giverny. Reprinted in *Claude Monet at the time of Giverny*.

31 From an interview with arts and political essayist Maurice Guillemot entitled "Claude Monet." Published in *La Revue Illustrée* on March 15, 1898. Reprinted in its entirety in *Monet: A Retrospective*.

32 1893, from a letter to his wife Alice. Monet was in Rouen to paint the cathedral. His letters from that period are filled with frustration and despair. The cathedral paintings were some of the most challenging works Monet created. Reprinted in *Claude Monet at the time of Giverny*.

35 From a 1927 article by François Thiébault-Sisson, published in the January edition of *Le Temps*. Reprinted in *Monet: A Retrospective*.

37 From a letter to Monet's friend and art dealer Paul Durand-Ruel, 1884, when Monet was in Bordighera. Durand-Ruel was an early supporter of Monet and their correspondence makes fascinating reading. Reprinted in *Claude Monet at the time of Giverny*.

38 Letter to fellow painter Bazille, 1868, from Le Havre where Monet had leased a house with his wife Camille and their son. Quoted in *Claude Monet: Life and Art*.

40 A favorite phrase of Monet's. Excerpted from Theodore Robinson's essay "Claude Monet," published in 1892 in *The Century Magazine*. Reprinted in its entirety in *Monet: A Retrospective*.

43 Letter to Alice Monet dated March 25, 1897, while Monet was painting in Pourville. Reprinted in *Claude Monet at the time of Giverny*.

45 Phrase from a January 12, 1884, letter to Durand-Ruel. Appears in *Monet: Life and Art*. Alternate translation printed in *Claude Monet at the time of Giverny*.

46 No date. Remark to Gustav Geffroy. Recorded in an article by William C. Seitz, "Monet and Abstract Painting," originally published in 1956 in *The College Art Journal* and reprinted in its entirety in *Claude Monet: Life and Art*.

49 From an 1884 letter sent from Bordighera. Reprinted in *Claude Monet at the time of Giverny*.

50 1909, Roger Marx. Reprinted in *Monet: A Retrospective*.

52 Monet in 1918 explaining why he couldn't receive visitors at Giverny. The painter did not like to be disturbed while painting and could be quite surly to those who arrived uninvited. Quoted in *Diary of an Art Dealer: 1918-1923* by René Gimpel. Reprinted in *Monet: A Retrospective*.

54 No date. Letter to Geffroy. *Claude Monet at the time of Giverny*.

57 No date. Frequently quoted advice given by Monet to a student painter. This translation appears in *Claude Monet* by William C. Seitz.

58 March 21, 1884. From a letter to Alice Hoschedé, soon to be Monet's second wife. Appears in *Claude Monet: Life and Art*.

60 Passage quoted in many sources. Translation from "Pilgrimage à Giverny" by Duc de Trévise, originally published in *La Revue de l'art ancien et moderne* (Jan/Feb 1927). Reprinted in its entirety in *Monet: A Retrospective*.

63 From an 1883 letter to Alice Hoschedé. Monet was painting in Bordighera and found it difficult to empathize with the lush, opulent Mediterranean landscape. Reprinted in its entirety in *Claude Monet at the time of Giverny*.

65 From an interview with Marc Elder entitled "Á Giverny, chez Claude Monet" (Paris: 1924). Reprinted in *Monet's Years at Giverny: Beyond Impressionism*. Exhibition catalog organized by The Metropolitan Museum of Art. (New York: MET) Copyright 1978 by The Metropolitan Museum of Art.

67 Remark to journalist in 1870 after painting the church at Vernon. This effect was the inspiration for the Rouen cathedral series. *Claude Monet: Life and Art*.

69 April 1892 letter to Alice Monet from Rouen. His letters from this period ring with frustration and anxiety as he struggled to represent the infinitesimal changes in light

as the sun passed over the façade of the cathedral. Reprinted in *Claude Monet at the time of Giverny*.

71 1903 letter to Durand-Ruel. Published by L. Venturi in *Hommage à Claude Monet*. Reprinted in *Claude Monet at the time of Giverny*. Monet's London canvases were the first sets of "series paintings" to make up an entire exhibition, an extraordinary concept at that time.

73 Ibid.

74 Letter to Gustav Geffroy in December of 1908. A record of their correspondence appears in Geffroy's 1924 biography of Monet, *Monet: Sa vie, son temps, son ouevre*. Monet, accompanied by his wife, went to Venice in the fall of that year specifically to paint. He brought back a series of thirty paintings. This phrase is reprinted in *Claude Monet* by William C. Seitz.

77 Remark to Émile Taboureux in *La Vie Moderne*, June 12, 1880. Appears in *Monet: A Retrospective*.

78 No date. Remark to an interviewer. Appears in *Claude Monet: Life and Art*.

80 June 22, 1890. From a letter to Geffroy. Appears in *Claude Monet at the time of Giverny*.

82 Comment made in "Claude Monet's Waterlilies," by Thiébault-Sisson. Published in 1927 in *La Revue d l'art ancien et moderne*. Reprinted in its entirety in *Monet: A Retrospective*.

84 Ibid.

87 Quoted by Thiébault-Sisson in his article "About Claude Monet," originally published in the December 29, 1926, edition of *Le Temps*. Reprinted in its entirety in *Monet: A Retrospective*.

89 No date. Matisse often said this about his later work when he was experimenting with different and darker palettes. Recorded by Clemenceau. Reprinted in *Claude Monet at the time of Giverny*.

91 Complaint to a doctor at Giverny in June 1924. Monet's sight was dimming and he was diagnosed with degenerative cataracts. After several operations he recovered his sense of color. *Claude Monet: Life and Art*.

96 Famous statement recorded by Clemenceau in 1929. Translation appears in *Monet: A Retrospective*.

LIST OF PLATES

and Francine Clark Art Institute, Williamstown, Massachusetts

53 *Bordighera,* 1884/Oil on canvas, 64.8 x 81.3 cm/Mr. and Mrs. Potter Palmer Collection, 1922.426/Photograph © 1994, The Art Institute of Chicago, All Rights Reserved

55 *The Petite Creuse,* 1888-9/Oil on canvas, 65.9 x 93.1 cm/Mr. and Mrs. Potter Palmer Collection, 1922.432/ Photograph © 1993, The Art Institute of Chicago, All Rights Reserved

56 *A Bend in the Epte River, Near Giverny,* 1888/Oil on canvas/Philadelphia Museum of Art/The William L. Elkins Collection

59 *Woman with a Parasol—Madame Monet and Her Son,* 1875/Oil on canvas/Collection of Mr. and Mrs. Paul Mellon/© 1995 Board of Trustees, National Gallery of Art, Washington

60 *Haystacks (Effect of Snow and Sun),* 1891/Metropolitan Museum of Art/ Bequest of Mrs. H.O. Havemeyer, 1929. The H.O. Havemeyer Collection (29.100.109)/Photograph copyright © 1984/1989 by The Metropolitan Museum of Art

61 *Grainstack (Sunset),* 1890-91/Oil on canvas/Juliana Cheney Edwards Collection/Courtesy, Museum of Fine Arts, Boston

62 *Meadow at Giverny,* 1894/Oil on canvas/The Art Museum, Princeton University/Bequest of Henry K. Dick

64 *Morning on the Seine Near Giverny,* 1897/Oil on canvas/The Metropolitan Museum of Art/Bequest of Julia W. Emmons, 1956 (56.135.4)/Photograph by Malcolm Varon, copyright © 1984 by The Metropolitan Museum of Art

65 *The Seine at Giverny,* 1897/Oil on canvas/Chester Dale Collection/©

1995 Board of Trustees, National Gallery of Art, Washington

66 *Old Church at Vernon,* 1896-7/Oil on canvas/Shelburne Museum, Shelburne, Vermont/Photograph by Ken Burris

68 *Rouen Cathedral Façade,* 1894/Oil on canvas/Juliana Cheney Edwards Collection/Courtesy, Museum of Fine Arts, Boston

69 *Rouen Cathedral Façade,* 1893/ Musée d'Orsay, Paris/Photograph © 1996, R.M.N.

70 *Houses of Parliament, Sun through Fog,* 1903/Musée d'Orsay, Paris/Photograph © 1996, R.M.N.

71 *The Houses of Parliament, Sunset,* 1903/Oil on canvas/Chester Dale Collection/© 1995 Board of Trustees, National Gallery of Art, Washington

72 *Charing Cross Bridge (Overcast Day),* 1899-1900/Oil on canvas/ Given by Janet Hubbard Stevens in memory of her mother, Janet Watson Hubbard/Courtesy, Museum of Fine Arts, Boston

75 *Palazzo da Mula, Venice,* 1908/Oil on linen/Chester Dale Collection/© 1995 Board of Trustees, National Gallery of Art, Washington

76 *Garden Path at Giverny,* 1902/Oil on canvas/Österreichische Galerie, Belvedere, Vienna, Austria

79 *Waterlilies and Japanese Bridge,* 1899/Oil on canvas/The Art Museum, Princeton University/From the collection of William Church Osborn, Class of 1883, Trustee of Princeton University (1914-1951), President of The Metropolitan Museum of Art (1941-1947); gift of his family. Photo: Clem Fiori

81 (also cover) *Water Lilies,* 1906 /Oil on canvas, 87.6 x 92.7 cm/Mr. and Mrs. Martin A. Ryerson Collection, 1933.1157/Photograph © 1994, The Art Institute of Chicago, All Rights Reserved

82-83 *Water Lilies,* 1897-8/Oil on canvas/ Los Angeles County Museum of Art/ Bequest of Mrs. Fred Hathaway Bixby

85 *Water Lily Pool,* 1900/Oil on canvas, 89.9 x 101 cm/Mr. and Mrs. Lewis Larned Coburn Memorial Collection, 1933.441/Photograph © 1994, Art Institute of Chicago, All Rights Reserved

86 *Les Hemerocallis,* 1914-17/Musée Marmottan, Paris/Photograph © 1996, Musée Marmottan

88 *Nymphéas: Pont Japonais,* ca. 1922/ Oil on canvas/The Minneapolis Institute of Arts /Bequest of Putnam Dana McMillan

90-91 *Yellow and Mauve Irises*/Musée Marmottan, Paris/Photograph © 1996, Musée Marmottan

All I did was to look at what
the universe showed me,
to let my brush bear witness to it.